I'd
RATHER
BE
Reading

I'd
RATHER
BE
Reading

a library of art for book lovers

By Guinevere de la Mare

With essays by Maura Kelly, Ann Patchett,
and Gretchen Rubin

CHRONICLE BOOKS
San Francisco

Library of Congress Cataloging-in-Publication Data:

De la Mare, Guinevere, 1976- | Kelly, Maura, 1974- | Rubin, Gretchen.| Patchett, Ann.

I'd rather be reading : a library of art for book lovers / by Guinevere de la Mare ; with
essays by Maura Kelly, Gretchen Rubin, and Ann Patchett.

San Francisco : Chronicle Books, 2017.
LCCN 2016051057 | ISBN 9781452155111 (alk. paper)
LCSH: Books and reading—Miscellanea.
LCC Z1003 .1225 2017 | DDC 028/.9—dc23
LC record available at https://lccn.loc.gov/2016051057

Manufactured in China

MIX
Paper from
responsible sources
FSC™ C136333

Design by Sara Schneider

10 9 8 7 6 5 4 3 2

Chronicle Books LLC
680 Second Street
San Francisco, California 94107
www.chroniclebooks.com

Chronicle books and gifts are available at special quantity discounts to
corporations, professional associations, literacy programs, and other organiza-
tions. For details and discount information, please contact our premiums depart-
ment at corporatesales@chroniclebooks.com or at 1-800-759-0190.

FOR MY GRANDMOTHERS,

Doris & Patricia,

WHO LOVED TO READ.
THANK YOU FOR TEACHING ME THAT
BOOKS ARE MAGIC.

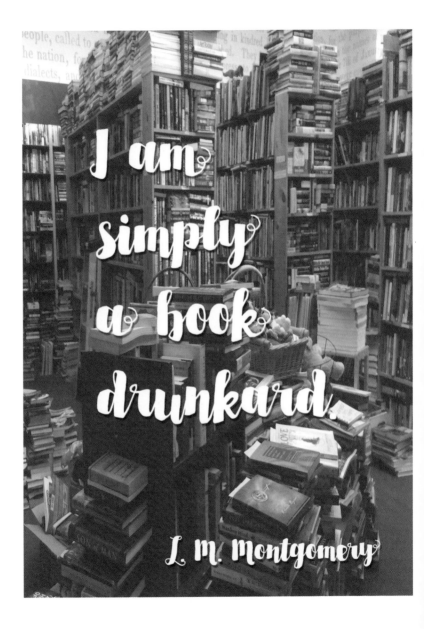

I am simply a book drunkard.

L. M. Montgomery

I'D RATHER BE Reading

THE AUTOBIOGRAPHY OF A BOOKWORM
By Guinevere de la Mare

Read any essay about the love of books and the author will undoubtedly mention an obsession with reading born in early childhood. My story starts with a twist. I had no interest in learning to read. When it came time to begin the process of decoding diphthongs and navigating the minefield of i's before e's except after c's, I said, "No thanks."

My kindergarten class was divided into small groups of four or five students, and I became ringleader of my group, convincing the other members that we had far better things to do than waste our time on those pesky lined work sheets. There were block towers to build! Dress-up games to be played! Reading was for suckers.

My teacher, Mrs. Schmidt, was a smart lady. She cocked an eyebrow and then wisely let me lead this rebellion unfettered. "Suit yourselves," she told us. But there would be no block building or dress-up corner privileges. We could sit quietly while the rest of the class learned to read. Fair enough. I was too busy basking in my newfound power to consider the consequences.

At first, the other kids in the class—those who hadn't been brave enough to stand up to Big Literacy—were envious of the freedom that

allowed us to doodle at our desks during reading time. But after a few days, something began to shift. We began to get bored. And all the other kids started to be able to do something we couldn't. They were looking at letters *but seeing words*. Suddenly they had a superpower, and we didn't. My days of academic protest were over.

The story has become family lore. I've heard it retold by my mother countless times, and truthfully, I have no memory of a time when I couldn't read. Looking back, I've got to hand it to Mrs. Schmidt. My grandmother was the director of the school—and her boss. I can only imagine the conversation at the staff meeting that particular week. "Well, Doris," I picture my teacher reporting, "your granddaughter has informed us that she won't be learning how to read." I'm sure they had a good laugh.

My grandmother was born on a chicken farm in Kansas and graduated from UCLA. In 1949, as a young mother of two, she set sail for Honolulu. My grandfather had been hired to be the chaplain at Punahou School, and together they raised five children in Hawaii. When her youngest started preschool, she began teaching. My grandfather died in 1974, two years before I was born. By then, my grandmother had been promoted to director of Central Union Preschool, where she worked until retirement.

I owe my love of reading to my grandmother. The preschool was an extension of her, and I grew up surrounded by books. My earliest memory is of being carried as a three-year-old from her office to my classroom. My siblings, cousins, and I all attended her school, and we spent countless hours at her house, curled up with books on the pūne'e (a basket-shaped Hawaiian daybed). Five of my cousins grew up on the mainland, but reading was so important to Gramsie (as we called her) that she would record cassette tapes for each of them, reading aloud the books she sent each birthday.

In our family, books were treasured gifts that were exchanged on every holiday. I still have a shelfful of Golden Books, each one inscribed

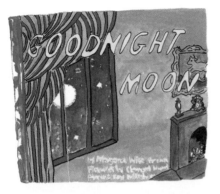

with the date and occasion: Christmas 1977, from my mother; Valentine's Day 1978, from my father; Easter 1982, from my sister. As a five-year-old, I probably couldn't have imagined a world where there wouldn't be someone at hand just waiting for the chance to read to me. Why bother learning to do it alone? Where was the fun in that?

Gramsie died a few years ago, shortly after my son was born. She was able to meet him once, and I have a cherished photograph of her beaming down at his three-month-old face. I still miss her, but I know just where to find her when I'm feeling down. My first copy of *Goodnight Moon* is tattered—a piece of clear packing tape runs down the spine, holding it together—but inside, there is magic. When I open the cover, my grandmother's handwriting is waiting for me. It is her voice I hear when I reread my favorite books from childhood.

By the time I was ten, I was a binge reader. I loved series best, when one book picked up where the previous one left off. Beatrix Potter, Curious George, and the Berenstain Bears led to Beverly Cleary, C. S. Lewis, and Madeleine L'Engle. By the time I finished the Little House books, I was ready for *Anne of Green Gables*. Anne Shirley was seventy-five years old by the time L. M. Montgomery retired her, and

I was *still* heartbroken when the series ended. Then came the Baby-Sitters Club and Sweet Valley High. It was like cheap boxed wine for a closet alcoholic. You could keep topping off the glass and no one would see the empty bottles stacking up. Reading was *good* for you; it didn't matter if the writing was crap. Just one more chapter. I can stop anytime.

If one grandmother got me hooked on reading, it was the other who staged an intervention. Grandma Harrison was born and raised on the Upper East Side of New York City. Her mother was a stage actress who had performed in Paris, London, and New York before she married. Her father was a prominent lawyer for the Southern Pacific Railroad. As the only child of two only children, she had a glamorous but lonely childhood. In the (sadly unfinished) memoirs she wrote at the end of her life, she vividly recalls the moment in school when she learned to read:

> There was always a period in the morning when the children were directed over to the bookcase to pick out any picture book they pleased. I picked out a big flat book called *The Sunbonnet Twins*. I had seen it before but when I opened it up, suddenly I could read every word on each page. I was very excited. I went over to the teacher. She was excited too. "I can read," I announced to Miss Mil when she came to pick me up. When we got home I went over to my bookcase, pulled out a book called *Bunny Bright Eyes*, and read it from cover to cover.

> From that day my life changed. I became a bookworm—sometimes to my mother's annoyance. She would come into the nursery to play only to find my nose in a book I didn't want to put down. For an only child, the love of books was a wonderful gift.

Grandma's generation *dressed* for dinner, and six o'clock on the dot was cocktail hour. My first memory of being chided for reading was during one of these cocktail hours. My grandfather mixed highballs at the bar cart while the adults got into lively debates about politics, current events, and whatever else Grandma was holding court about on that particular day. As children, my sister and I usually sat on the rug, snacking on goldfish crackers, bored to tears by all the grown-up talk. So one day I plonked down in an armchair in the corner and disappeared behind my book. I don't remember her words on the day of the intervention, but oh, I remember my grandmother's tone. This was *not* acceptable behavior in polite company. I wasn't completely feral—I knew better than to read at the dinner table. But, much to my introvert chagrin, hiding behind a book to avoid small talk was not an option. There was a time and a place for reading. Everything in moderation.

During long summer vacations and snowy Christmas holidays at my grandparents' farmhouse in Vermont, I roamed freely among the many bookshelves. When I was twelve, I traveled as an unaccompanied minor for a solo visit with my grandparents. It was a rite of passage for the grandchildren. My older sister had visited Berlin with them just before the fall of the wall, but my trip was decidedly less epic. There are only two things I recall: I got my first migraine while watching the high dive at a traveling circus on a scorchingly hot New England summer day, and I pulled two books off of Grandma's shelf—*Marjorie Morningstar*, by Herman Wouk, and *Rebecca*, by Daphne du Maurier.

These were the first truly adult books that I read. I had been reading questionably age-appropriate books for a few years—once Lois Duncan hit the scene with *I Know What You Did Last Summer*, it was a teen terror bonanza of Christopher Pike and V. C. Andrews for me. But these were young adult books, and the tropes, plot twists, and characters had the subtlety and depth of a kiddie pool. It was *Rebecca* that pushed me into the deep end. I discovered

Gothic literature—*Jane Eyre*, Mary Shelley's *Frankenstein*, *Wuthering Heights*—the more tragic, the better.

Anyone who doubts the studies that show reading fiction increases empathy surely wasn't a bookworm as a child. Long before anyone close to me died, before I learned that boys could break my heart, fictional tragedies were the worst things that happened to me. I shed real tears over *A Little Princess*, *Where the Red Fern Grows*, *Charlotte's Web*, *Old Yeller*, *The Velveteen Rabbit*, *Bridge to Terabithia*—my God, I don't think I could get through *Bridge to Terabithia* dry-eyed today. I was extremely fortunate. Terrible things did happen to people I knew—a second-grade classmate was shot and killed by her uncle, the daughter of family friends was kidnapped and murdered, a boy in my sister's class died in a car accident—but nothing truly horrible happened to me or my family. We were lucky, and thanks to books, I had the self-awareness to realize it.

My parents divorced when I was thirteen, and I bid adieu to childhood. My older sister was sixteen, and she promptly bailed to enjoy an entirely unsupervised life as the roommate of our newly swinging bachelor of a dad. My younger siblings were five and one, still babies, and my mom, depressed and overwhelmed by single motherhood, fell apart. She began drinking and soon became an alcoholic. When I went in search of something to read, I would find abandoned coffee mugs half-filled with Chardonnay on the bookshelf. Someone had to be the adult in our household, and too young to know any better, I stepped into the role. Since I was a reader, I constantly held up my own life to the mirror of the lives I read about. Literature gave me perspective. Things could be so much worse. I mean, look at *Ellen Foster*! This wasn't the *Summer of My German Soldier*. Anne Frank I was not.

I was a good student—that momentary lapse in kindergarten was a one-off—and in junior high, my English teacher assigned us *The*

Count of Monte Cristo. It was my first *big* book, and I loved it. I can still remember the heft of those five hundred pages and the sense of pride and accomplishment I felt finishing off the tome. My introduction to Alexandre Dumas began a love affair with the Romantics: Stendhal, Flaubert, Baudelaire. Looking back, it's pretty clear that escapist literature was my coping mechanism. The quotidian affairs of Jane Austen and Louisa May Alcott didn't particularly interest me back then. I wanted big sweeping action and adventure. Tragic love affairs. Unhappy endings. The teenage drama queens of Sweet Valley High led me straight down the path to Madame Bovary and Lady Chatterley.

My first breakup with books occurred during my senior year of high school. Until then, I was predestined to be an English major in college. I had won writing and English awards at school, and as a sophomore, I took a Shakespeare seminar with upperclassmen as an elective. You know, *for fun*. All that changed in AP English. The reading list was challenging: Virginia Woolf's *To the Lighthouse*, James Joyce's *A Portrait of the Artist as a Young Man*, "The Yellow Wallpaper" by Charlotte Perkins Gilman. Our teacher, Dr. Lynch, taught us the art of close reading, or how to analyze a text deeply. We spent class after class decoding symbolism, debating the intention of the author, constructing and reconstructing thesis statements. And I hated every minute of it. Critical analysis killed my love of reading.

I had a crisis of confidence. I was not a born critic. I didn't trust my own opinions, or even my authority to have an opinion. What happened to willingly suspending our disbelief? Why insist on destroying the magic of letting a book transport you? How should we know what an author's intention might have been? Those class discussions drove me crazy. Every time a pimply teenager espoused some half-baked theory about what Woolf was *thinking*, I wanted to scream. I had always read for pleasure—I didn't believe reading should feel like work. I enrolled in exactly one English class at UC Berkeley, just

enough to satisfy the liberal arts requirement. When the professor praised my writing and recommended I join the student-run newspaper, *The Daily Californian*, I ignored him. I was a lover, not a writer.

As an adult, my bookshelves defined me. In the days before Goodreads and Google stalking, you had to judge potential friends and mates by their actions, their personalities, and their stuff. I was disdainful of acquaintances who didn't fill their apartments with books. I dated men based on their bookshelves. When my future husband and I moved across the country so that he could attend grad school in Providence, Rhode Island—and again on the return trip to San Francisco two and a half years later—we exceeded the weight limit on our door-to-door moving crates and paid a stiff penalty. When we joined our personal libraries in matrimony, we had thousands of books, and shelves in every room.

The longest I ever went without reading were the first two years of my son's life. After he was born, I lost myself. Sleep deprivation and the arrival of the iPhone conspired to keep me from books. I worked in publishing and was surrounded by books every day, but when I collapsed into bed at night, all I could muster the energy for was thumbing mindlessly through Facebook. I wasn't reading for pleasure. I plowed hopelessly through stacks of baby books, seeking a solution for the sleepless nights that dragged on for nineteen months. (A plague on all your houses, sleep experts!) Every six weeks or so, I scrambled to finish whatever book we were scheduled to discuss at book club. It felt like homework. For the first time in my life, I found no escape and no comfort in reading.

Thankfully the old parenting adage that "the days are long but the years are short" is also the truth. I'm back to my old self, a reader to the core. Now that my son is old enough to enjoy long chapter books before bed, I've had the pure joy of rediscovering old favorites and experiencing new books with him. It was a delight to realize that *The*

Phantom Tollbooth was just as good (better even?) than I remembered it. We read *Charlie and the Chocolate Factory*, and I couldn't believe I hadn't read it before. And Harry Potter. Oh, Harry Potter!

For my son's sixth birthday, I gave him the illustrated edition of *Harry Potter and the Sorcerer's Stone* with gorgeous full-color paintings by Jim Kay. When the series first came out, I was still in college, studying abroad in Italy. I was too busy at the school of Chianti and Prosecco to get fired up about wizards. Now I get it. Rereading the first two books through the eyes of a six-year-old boy, I fully appreciate the genius of J. K. Rowling. When we finished the first book, we immediately flipped back to the beginning and started it again the next night (although we skipped the Muggle chapters and headed straight to Hogwarts, by request). The next time we finished, we went out and bought book two the following day. I don't think he's old enough for Death Eaters, so I've told him he has to wait a bit for the next one. Until then, he's biding his time, dressing up in his Jedi-turned-Hogwarts robe and casting imaginary spells around the house. In April, he announced that he wanted to be Harry Potter for Halloween.

Toward the end of the school year, my son's kindergarten teachers gave a presentation to the parents about what the students had been learning. Some parents were concerned that their children were not yet reading. It's a progressive school, an Italian-immersion program. At six, my child can speak Italian, but he can only read the simplest of words. I almost laughed out loud when the teachers defended themselves: "We are confident that every student in our class could read, if we forced them to. We choose not to."

Mrs. Schmidt would have been proud. Gramsie would have cheered. Of course these children will learn to read. Probably over the summer, if we all chilled out with the camps and sports and screens and let our kids get bored more often. Books are the best remedy for

boredom, but it's a remedy you have to discover for yourself. Just like my friends and I did in that kindergarten classroom in Honolulu.

I have no doubt that my son will be a reader. He may not be as single-minded about it as I am, and that's fine, but it's in his blood. His parents are readers. His grandparents are readers. Every home he visits, on every family vacation, is filled with books. Snuggling up next to my son and reading aloud every night before bed is my favorite part of the day. I survived those first two sleepless years; I know that time is short, that this window is closing. Soon he'll be reading on his own and I'll be the one calling him to the dinner table, pulling him out from behind the book.

The love of reading that has passed down through generations of my family is the greatest gift that I could imagine and the greatest legacy I can leave my child. I am so lucky to have been raised as a reader. The essayist Rebecca Solnit once wrote, "A book is a heart that only beats in the chest of another." When we read together, our hearts beat as one. At least that's what my grandmothers taught me.

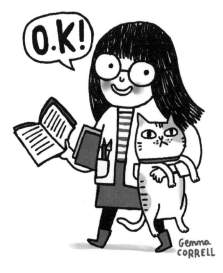

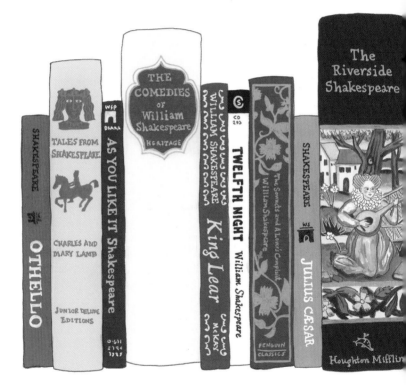

SHAKESPEARE

OTHELLO

TALES FROM SHAKESPEARE

CHARLES AND MARY LAMB

JUNIOR DELUXE EDITIONS

WSP
DIANA

AS YOU LIKE IT Shakespeare

0-671
5194
1737

THE COMEDIES of William Shakespeare

HERITAGE

WILLIAM SHAKESPEARE

C
CO
293

King Lear

McKay

TWELFTH NIGHT William Shakespeare

The Sonnets and A Lover's Complaint William Shakespeare

PENGUIN CLASSICS

SHAKESPEARE

WS

JULIUS CÆSAR

The Riverside Shakespeare

Houghton Mifflin

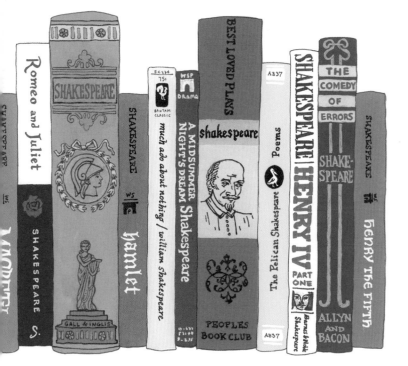

CHAYEEPEARE

WS

MACBETH

S.

Romeo and Juliet

SHAKESPEARE

SHAKESPEARE

WS

hamlet

SC234
75¢
BANTAM
CLASSIC

much ado about nothing / william shakespeare

0-671
55144
9-275

WSP
DRAMA

A MIDSUMMER NIGHT'S DREAM Shakespeare

BEST LOVED PLAYS

shakespeare

PEOPLES
BOOK CLUB

AB37

The Pelican Shakespeare Poems

AB37

SHAKESPEARE HENRY IV

PART
ONE

Barnes & Noble Shakespeare

THE
COMEDY
OF
ERRORS

SHAKE-
SPEARE

ALLYN
AND
BACON

SHAKESPEARE

WS

henry the fifth

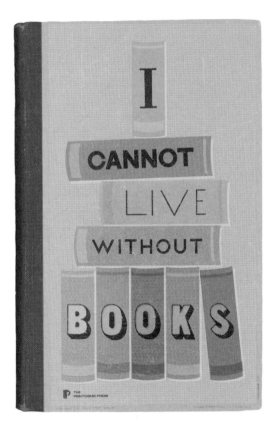

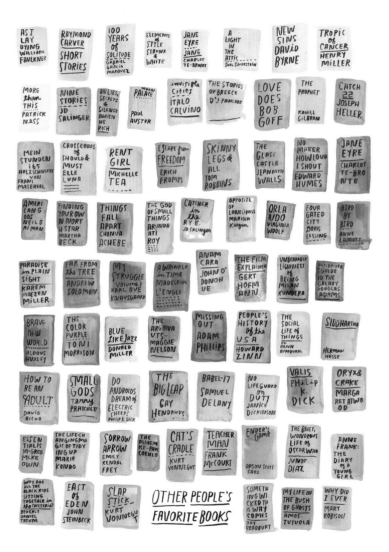

AS I LAY DYING WILLIAM FAULKNER

RAYMOND CARVER SHORT STORIES

100 YEARS of SOLITUDE GABRIEL GARCIA MARQUEZ

ELEMENTS of STYLE STRUNK & WHITE

JANE EYRE JANE CHARLOTTE-BRONTE

A LIGHT in THE ATTIC SHEL SILVERSTEIN

NEW SINS DAVID BYRNE

TROPIC of CANCER HENRY MILLER

MORE than THIS PATRICK NESS

NINE STORIES JD SALINGER

ON LIES, SECRETS & SILENCE ADRIENNE RICH

MOON PALACE PAUL AUSTER

invisible Cities ITALO CALVINO

THE STORIES OF BREECE D'J PANCAKE

LOVE DOES BOB GOFF

THE PROPHET KAHILL GILBRAN

CATCH 22 JOSEPH HELLER

MEIN STUNDEN 165 HOLZSCHNITTE VON FRANS MASEREEL

CROSSROADS of SHOULD & MUST ELLE LUNA

RENT GIRL MICHELLE TEA

ESCAPE from FREEDOM ERICH FROMM

SKINNY LEGS & ALL TOM ROBBINS

THE GLASS CASTLE JEANNETTE WALLS

NO MATTER HOW LOUD I SHOUT EDWARD HUMES

JANE EYRE CHARLOTTE-BRONTE

AMERICAN GODS NEIL GAIMAN

FINDING YOUR OWN NORTH STAR MARTHA BECK

THINGS FALL APART CHINUA ACHEBE

THE GOD OF SMALL THINGS ARUNDHATI ROY

CATCHER in the RYE JD SALINGER

OPPOSITE OF LONELINESS MARINA Keegan

ORLANDO VIRGINIA WOOLF

FOUR GATED CITY DORIS LESSING

BIRD BY BIRD ANNE LAMOTT

PARADISE in PLAIN SIGHT KAREM MAEZEN MILLER

FAR FROM the TREE ANDREW SOLOMON

MY STRUGGLE Volume 1 KARL OVE KNAUSGAARD

A WRINKLE in TIME MADELEINE L'ENGLE

ANAM CARA JOHN O'DONOHUE

THE FILM EXPLAINER GERT HOFMANN

UNBEARABLE LIGHTNESS of BEING MILAN KUNDERA

HITCHHIKER GUIDE TO THE GALAXY DOUGLAS ADAMS

BRAVE NEW WORLD ALDOUS HUXLEY

THE COLOR PURPLE TONI MORRISON

BLUE LIKE JAZZ DONALD MILLER

THE ARGONAUTS MAGGIE NELSON

MISSING OUT ADAM PHILLIPS

PEOPLE'S HISTORY of the USA HOWARD ZINN

THE SOCIAL LIFE of THINGS ed. ARJUN APPADURAI

SIDDHARTHA HERMAN HESSE

HOW TO BE AN ADULT DAVID RICHO

SMALL GODS Terry PRATCHETT

DO ANDROIDS DREAM of ELECTRIC SHEEP? PHILIP K DICK

THE BIG LEAP GAY HENDRICKS

BABEL-17 SAMUEL DELANY

NO LIFEGUARD on DUTY JANICE DICKINSON

VALIS PHILIP K. DICK

ORYX & CRAKE MARGARET ATWOOD

ESSENTIALIS M-GREG MCKEOWN

THE LIFE-CHANGING MAGIC OF TIDYING UP MARIE KONDO

SORROW ARROW EMILY KENDAL FREY

THE ALCHEMIST-PAUL COELHO

CAT'S CRADLE KURT VONNEGUT

TEACHER MAN FRANK MCCOURT

ENDER'S GAME ORSON SCOTT CARD

THE BRIEF, WONDROUS LIFE of OSCAR WAO JUNOT DIAZ

ANNE FRANK: THE DIARY of A YOUNG GIRL

WHY ARE ALL THE BLACK KIDS SITTING TOGETHER in the CAFETERIA? BEVERLY DANIEL TATUM

EAST of EDEN JOHN STEINBECK

SLAPSTICK KURT VONNEGUT

OTHER PEOPLE'S FAVORITE BOOKS

SOMETHING WICKED THIS WAY COMES RAY BRADBURY

MY LIFE IN THE BUSH OF GHOSTS AMOS TUTUOLA

WHY DID I EVER MARY ROBISON

21

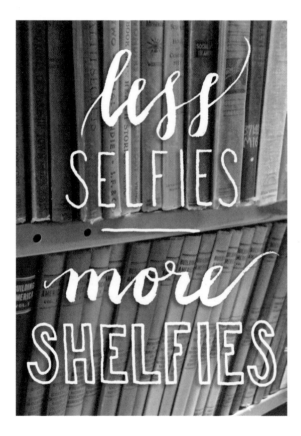

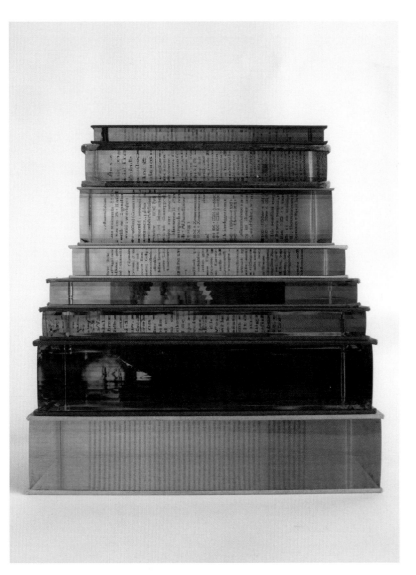

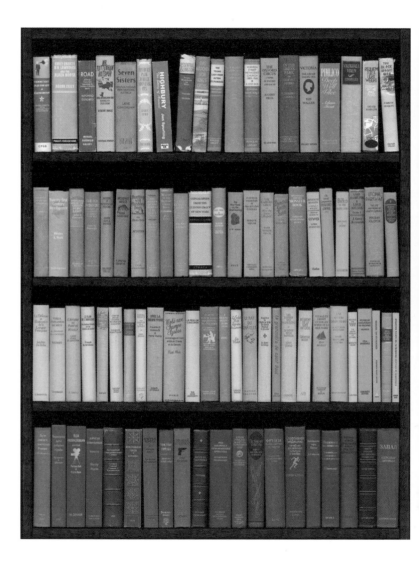

Books were his
favourite way
to escape.

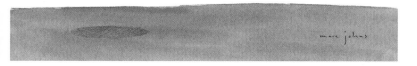

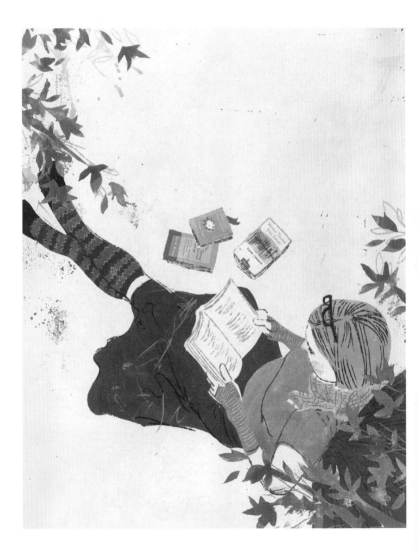

THERE IS NO FRIGATE LIKE A BOOK
TO TAKE US LANDS AWAY
NOR ANY COURSERS LIKE A PAGE
OF PRANCING POETRY—
THIS TRAVERSE MAY THE POOREST TAKE
WITHOUT OPPRESS OF TOLL—
HOW FRUGAL IS THE CHARIOT
THAT BEARS THE HUMAN SOUL—

— Emily Dickinson (1830–1886)

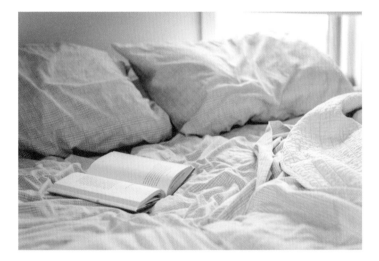

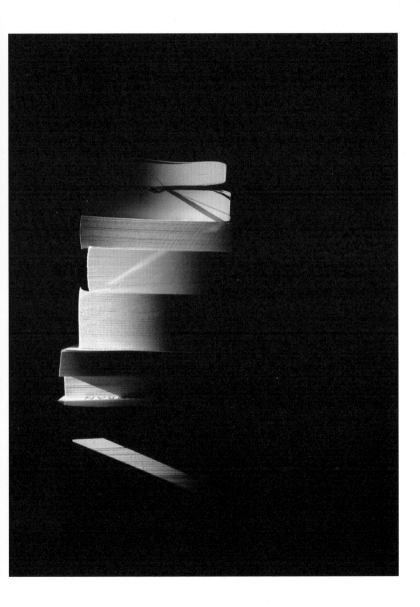

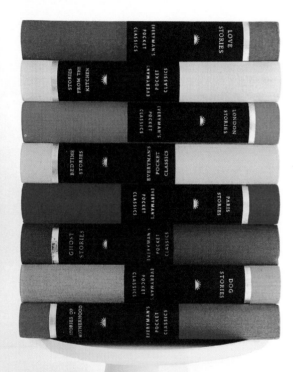

JOIE DE LIIVRES

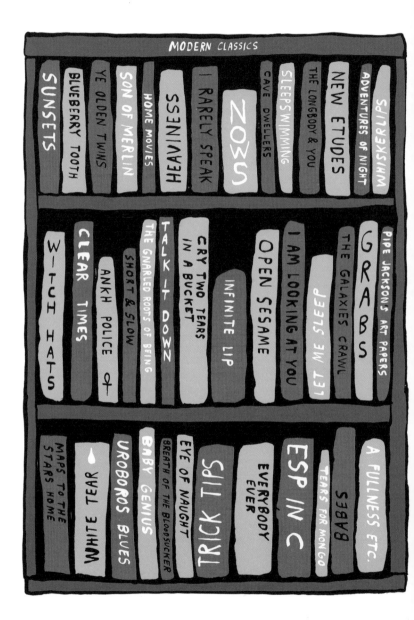

A SLOW BOOKS

Manifesto

By Maura Kelly

Everywhere you look these days, there's a new "slow" movement. Since 1989, when the activists behind the Slow Food Manifesto began calling on us to change the way we eat—arguing that meals that take time to prepare are better for our health, our world, and our happiness than faster foods—their ideas have steadily gained power. In recent years, splinter groups like the Slow Beer Movement and the Slow Cocktail Movement have formed. In 2013, Emily Matchar trumpeted an increasing trend among women (and a few men) to return to domesticity in her book, *Homeward Bound: Why Women Are Embracing the New Domesticity*. The effort unites a growing number of people interested in old-fashioned household activities—like making their own jams, whiskey, and pickled vegetables. They do it "both for fun and for a greater sense of control over what we eat," as Matchar wrote.

I'm all for efforts like these. But why so much emphasis on what goes into our mouths and so little on what goes into our minds? What about having fun while exerting greater control over what goes into your brain? Why hasn't a hip alliance emerged that's concerned about what happens to our intellectual health, our country, and, yes,

our happiness when we consume empty-calorie entertainment? The Slow Food Manifesto lauds "quieter pleasures" as a means of opposing "the universal folly of Fast Life"—yet there's little that seems more foolish, loudly unpleasant, and universal than the screens that blare in every corner of America (at the airport, at the gym, in the elevator, in our hands). "Fast" entertainment, consumed mindlessly as we slump on the couch or do our morning commute, pickles our brains—and our souls. That's why I'm calling for a Slow Books Movement.

In our leisure moments, whenever we have downtime, we should turn to literature—to works that took some time to write and will take some time to read, but will also stay with us longer than anything else. They'll help us unwind better than any electronic device—and they'll pleasurably sharpen our minds and identities, too.

To borrow a cadence from Michael Pollan: Read books. As often as you can. Mostly classics.

Aim for thirty minutes a day. You can squeeze in that half hour pretty easily, if only, during your free moments—whenever you find yourself automatically switching on that boob tube, or firing up your laptop to check your favorite site, or scanning Twitter for something to pass the time—you pick up a meaningful work of literature. Reach for your e-reader, if you like. The Slow Books Movement won't stand opposed to technology on purely nostalgic or aesthetic grounds. (Kindles et al. make books like *War and Peace* less heavy, not less substantive, and also ensure you'll never lose your place.)

But Slow Books *will* have standards about what kinds of reading materials count toward your daily quota. Blog posts won't, of course, but neither will newspaper pieces nor even magazine articles.

Also excluded: nonliterary books.

Why the emphasis on literature? By playing with language, plot structure, and images, it challenges us cognitively even as it entertains. It invites us to see the world in a different way, demands that we

interpret unusual descriptions, and pushes our memories to recall characters and plot details. In fact, as Annie Murphy Paul noted in a *New York Times* op-ed, neuroscientists have found plenty of proof that reading fiction stimulates all sorts of cognitive areas—not just language regions but also those responsible for coordinating movement and interpreting smells. Because literary books *are* so mentally invigorating and require such engagement, they make us smarter than other kinds of reading material, as a 2009 UC Santa Barbara study indicated. Researchers found that subjects who read Kafka's "A Country Doctor"—which includes feverish hallucinations from the narrator and surreal elements—performed better on a subsequent learning task than a control group that read a straightforward summary of the story. (They probably enjoyed themselves a lot more while reading, too.)

Literature doesn't just make us smarter, however; it makes us us, shaping our consciences and our identities. Strong narratives—from *Moby-Dick* to William Styron's suicide memoir, *Darkness Visible*—help us develop empathy. Research by Canadian psychologists Keith Oatley and Raymond Mar suggests that reading fiction even hones our social skills, as Paul notes in her op-ed: "Dr. Oatley and Dr. Mar, in collaboration with several other scientists, reported . . . that individuals who frequently read fiction seem to be better able to understand other people, empathize with them, and see the world from their perspective. This relationship persisted even after the researchers accounted for the possibility that more empathetic individuals might prefer reading novels."

With empathy comes self-awareness, of course. By discovering affinities between ourselves and characters we never imagined we'd be able to comprehend (like the accused murderer Dmitri Karamazov), we better understand who we are personally and politically; what we want to change; what we care about defending.

Best of all, perhaps, serious reading will make you feel good about yourself. Surveys show that TV viewing makes people unhappy and remorseful—but when has anyone ever felt anything but satisfied after finishing a classic? Or anything but intellectually stimulated after tearing through a work of modern lit like, say, Mary Gaitskill's *Veronica*?

And though a television show isn't likely to stay with you too long beyond the night that you watch it, once you've finished a slow book—whether it's as long as Tolstoy's epic or as short as *The Old Man and the Sea*, as old as *The Odyssey* or as new as Jonathan Franzen's *Freedom*, as funny as *Portnoy's Complaint* or as gorgeous as James Salter's *Light Years*—you'll have both a sense of accomplishment and the deeper joys of the book's most moving, thought-provoking, or hilarious passages. Time and again—to write that toast, enrich your understanding of a strange personal experience, or help yourself through a loss—you'll return to those dog-eared pages (or search for them on your Kindle). Eventually, you may get so good at reading that you'll move on to the slowest (and most rewarding) reading material around: great poems.

Meantime, if you're not reading slowly, you're doing yourself—and your community—a great wrong. As poet Joseph Brodsky said in his acceptance speech for the 1987 Nobel Prize in Literature, "Though we can condemn . . . the persecution of writers, acts of censorship, the burning of books, we are powerless when it comes to [the worst crime against literature]: that of not reading the books. For that . . . a person pays with his whole life . . . a nation . . . pays with its history."

A previous version of this essay appeared on theatlantic.com on March 26, 2012.
http://www.theatlantic.com/entertainment/archive/2012/03/a-slow-books-manifesto/254884/

unplug.

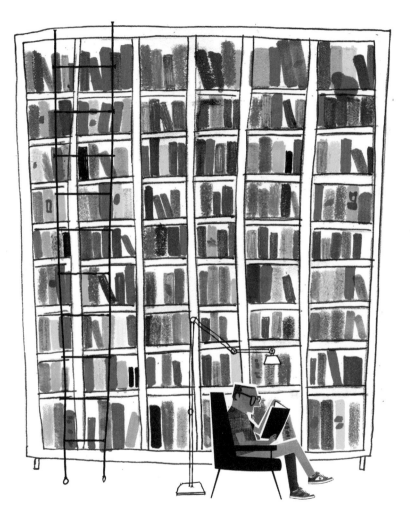

A BOOK
BE THE
THE FRO
SEA

—FRAN

MUST AXE FOR ZEN WITHIN US

AFKA—

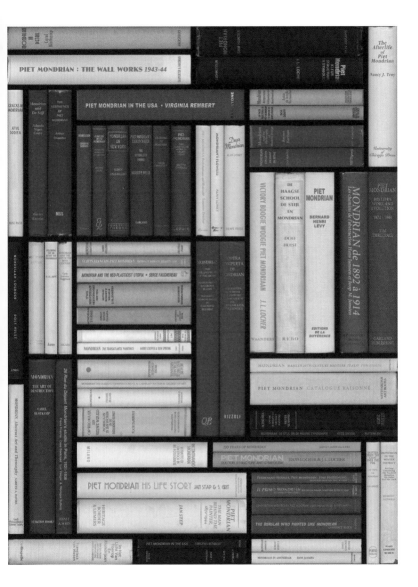

OH FOR A BOOK AND A SHADY NOOK,
EITHER INDOORS OR OUT,
WITH THE GREEN LEAVES WHISPERING OVERHEAD,
OR THE STREET CRIES ALL ABOUT.
WHERE I MAY READ AT ALL MY EASE
BOTH OF THE NEW AND OLD,
FOR A JOLLY GOOD BOOK WHEREON TO LOOK
IS BETTER TO ME THAN GOLD.

—John Wilson (1785–1854)

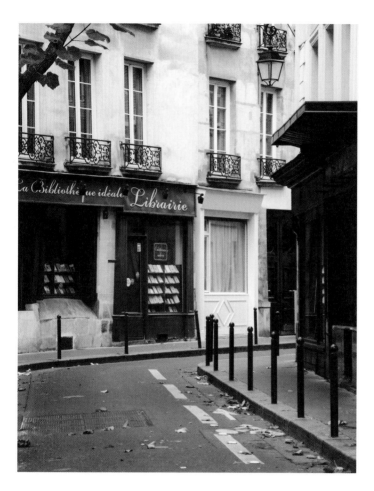

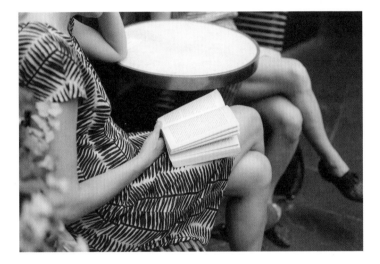

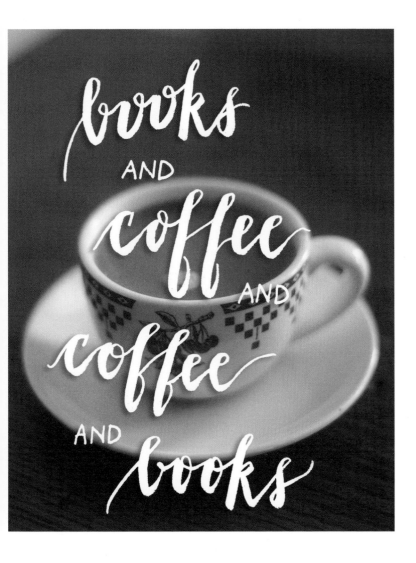

books AND coffee AND coffee AND books

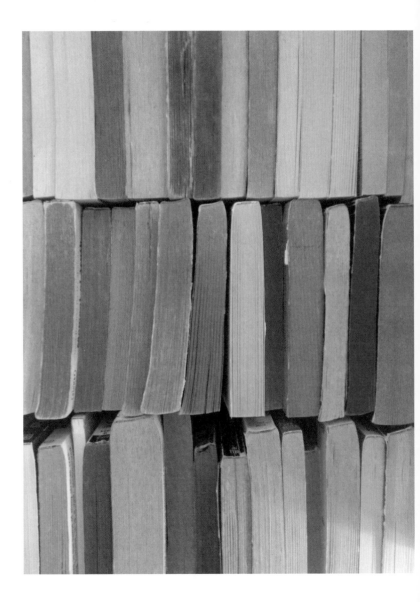

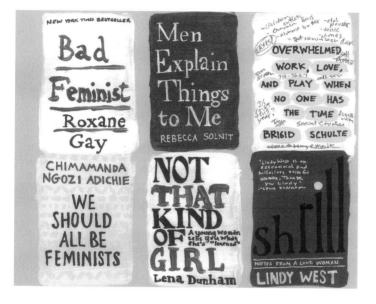

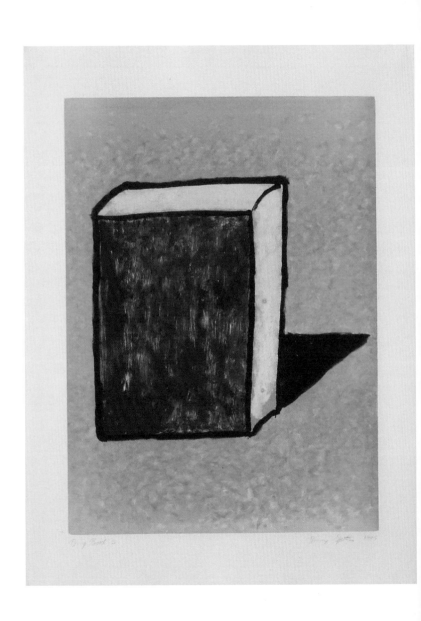

Cheating

By Ann Patchett

I often say that the one thing I'm most likely to do on any given day is answer five questions for a newspaper in Australia, by which I mean I spend a lot of my time filling out forms. None of them are hard, many of them are from other countries, and for the most part they're all pretty much the same. A very clever writer friend keeps a computer file of answers and just pastes them into different questionnaires. I keep meaning to be that organized.

This is one I did the other day. What was interesting about it was that it asked for my twenty-five favorite books. I'm often asked for my top three favorites, or top five, but never anything close to twenty-five. After the list, there were questions about favorite mysteries and favorite classics, which gave me room to add even more books to the list. *The Great Gatsby* is certainly one of my top twenty-five, but why use the space when I could work it in later? I was so surprised by the big number that I found myself really giving this project some thought. At first, twenty-five seemed like too many. Ten minutes later, it wasn't enough. I remember in 2000 someone came out with a list of the one hundred greatest books of the century. I printed it out and made a

point of reading the ones I'd neglected. I in no way think this list represents the greatest books of all time. I'm not even sure it represents my favorites. Do I really like *The All of It* better than *Moby-Dick*? Probably not, but I know I'd be more inclined to reach for it.

I was also surprised by my inability to add on books I love but had only recently read. I just finished William Trevor's *Fools of Fortune*—a fantastic book. It felt like a top twenty-five, but wasn't it too soon to commit? I also thought of the books that my friends have written that I love, but how could I include one or two without representing them all? So there are no friends on the list. There could be my favorite twenty-five books written by people I know, or my favorite twenty-five books written in the last twenty-five years. That would be a good one. I spent an hour trying to figure out which Toni Morrison was my favorite and got so exasperated with myself that I left her off. I cheated by including all four of Updike's Rabbit Angstrom novels as one volume, and then listed the two Nancy Mitford novels most often published together as one. I included very little nonfiction. *In Cold Blood* was on there for a while and then fell off, as was Mikal Gilmore's *Shot in the Heart*.

In short, this list is neither definitive nor true. Many days, I like *Sense and Sensibility* better than *Persuasion*, and maybe I like *The Portrait of a Lady* as much as I do *The Ambassadors*. I started overthinking everything. I told myself to stop. At the end of everything, I thought, *Hey, this could be a good entry for the blog I write for my bookstore, Parnassus Books.* It's cheating, sure, but I did read all these books and I loved them.

Now, onto the lists:

Name your twenty-five favorite books
(Alphabetical by author, not ranked.)

 Persuasion – Jane Austen

 Humboldt's Gift – Saul Bellow

 Jonathan Strange & Mr. Norrell – Susanna Clarke

 David Copperfield – Charles Dickens

 The Good Soldier – Ford Madox Ford

 Old Filth – Jane Gardam

 The All of It – Jeannette Haien

 Act One – Moss Hart

 The Ambassadors – Henry James

 The Leopard – Giuseppe di Lampedusa

 Independent People – Halldór Laxness

 The Perfect Spy – John le Carré

 The Magic Mountain – Thomas Mann

 One Hundred Years of Solitude – Gabriel García Márquez

 So Long, See You Tomorrow – William Maxwell

 The Pursuit of Love and *Love in a Cold Climate* – Nancy Mitford

 Selected Stories – Alice Munro

 Lolita – Vladimir Nabokov

 The Collected Stories – Grace Paley

 The Radetzky March – Joseph Roth

 The Human Stain – Philip Roth

 Her First American – Lore Segal

 Anna Karenina – Leo Tolstoy

 Rabbit Angstrom: The Four Novels – John Updike

 A Day at the Beach – Geoffrey Wolff

What are you reading right now?

 Fools of Fortune, by William Trevor. I think this is going to be my favorite Trevor novel.

What was your favorite children's book? Why?

 The Lonely Doll, by Dare Wright—a picture book. It's so sad and haunted and beautiful and full of anxiety. I loved the black-and-white photographs.

What book do you most often reread? Why?

 The Great Gatsby, by F. Scott Fitzgerald. I'll think of a sentence or a scene I want to read again, and I'll sit down and read the whole thing. It's a perfect novel, and it's very short.

What book would you want with you on a desert island? Why?

 The Man Without Qualities, by Robert Musil. It's enormously long and complicated, and I've been meaning to read it for years. I think I would need the quiet of a desert island in order to concentrate, and maybe by the time I finished, I would be rescued.

What book would you recommend to a friend? Why?

 It would depend on the friend. If the friend had strong nerves, I would recommend the Patrick Melrose novels (all five of them) by Edward St. Aubyn. I'm obsessed with these books but they aren't for the faint of heart.

What is your favorite biography? Why?

 The Fitzgeralds and the Kennedys, by Doris Kearns Goodwin. I've read all of her books, and this one is probably my favorite, but really, it could have been any of them.

What is your favorite holiday book? Why?

 "A Christmas Memory," by Truman Capote. Sometimes we all need a good, cathartic sob.

What is your favorite summer read? Why?

We Are All Completely Beside Ourselves, by Karen Joy Fowler. "Summer read" tends to be a nice way of saying "lightweight," which this book is not, but I read it this summer and I thought it was brilliant.

What is your favorite mystery? Why?

The Long Goodbye, by Raymond Chandler. I've read very few mysteries, but I love Chandler. This one was my favorite, possibly because it was the longest.

What book did you think made a better movie than it did a book? Why?

The Namesake, by Jhumpa Lahiri. The book was good but the movie was great. It's deeper, richer somehow. The acting was fantastic.

What book most influenced your life? Why?

Charlotte's Web, by E. B. White. It made me a vegetarian, and I convinced my parents to get me a pig for my ninth birthday.

What is your favorite classic?

Any Dickens, any Austen, any James.

What is your favorite coffee-table book?

Cabinet of Natural Curiosities, by Albertus Seba. It's huge, endlessly entertaining, and the one book that is actually on my coffee table.

This essay was first published on August 19, 2013, on Musing, *the online literary journal of Parnassus Books. Used by permission of the author. All rights reserved.*

I HAVE ALWAYS IMAGINED

PARADISE

WILL BE A KIND OF

LIBRARY

JORGE LUIS BORGES

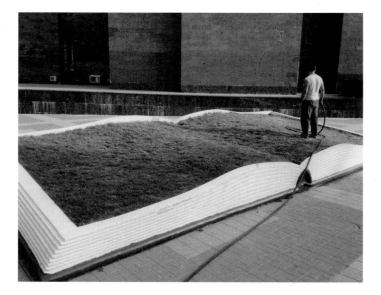

WITH FREEDOM, BOOKS, FLOWERS, AND tHE MOON, WHO COULD NOt BE HAPPY?

OSCAR WILDE

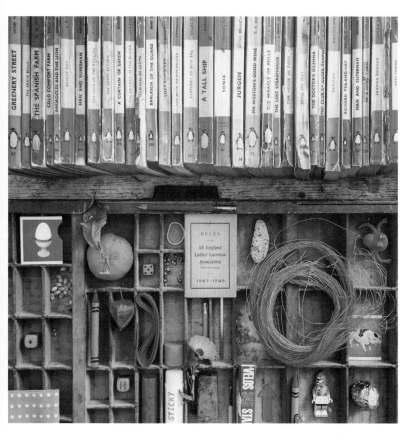

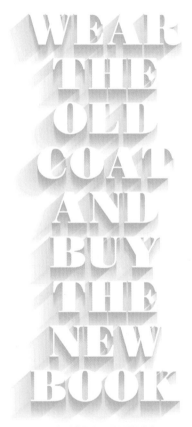

WEAR THE OLD COAT AND BUY THE NEW BOOK

AUSTIN PHELPS

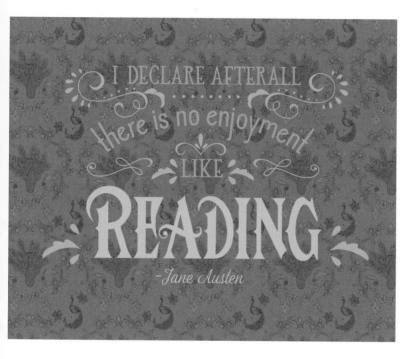

I DECLARE AFTERALL
there is no enjoyment
LIKE
READING

-Jane Austen

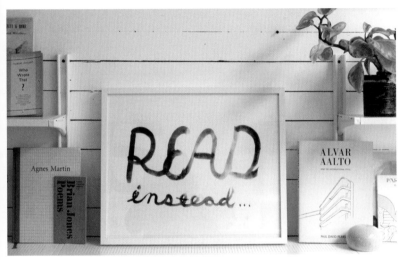

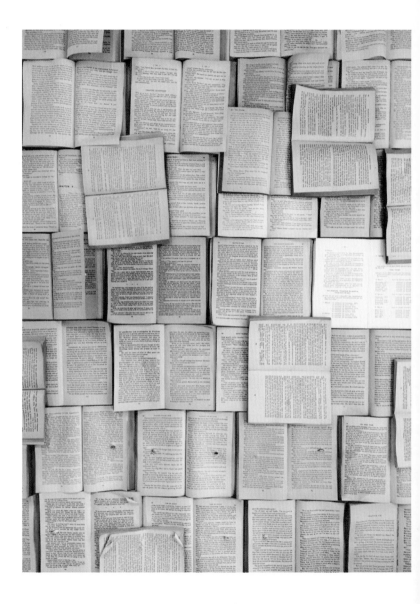

BOOKS, BOOKS, BOOKS!
I HAD FOUND THE SECRET OF A GARRET-ROOM
PILED HIGH WITH CASES IN MY FATHER'S NAME,
PILED HIGH, PACKED LARGE— WHERE, CREEPING IN AND OUT
AMONG THE GIANT FOSSILS OF MY PAST,
LIKE SOME SMALL NIMBLE MOUSE BETWEEN THE RIBS
OF A MASTODON, I NIBBLED HERE AND THERE
AT THIS OR THAT BOX, PULLING THROUGH THE GAP,
IN HEATS OF TERROR, HASTE, VICTORIOUS JOY,
THE FIRST BOOK FIRST. AND HOW I FELT IT BEAT
UNDER MY PILLOW, IN THE MORNING'S DARK,
AN HOUR BEFORE THE SUN WOULD LET ME READ!
MY BOOKS!

—Elizabeth Barrett Browning (1806–1861)

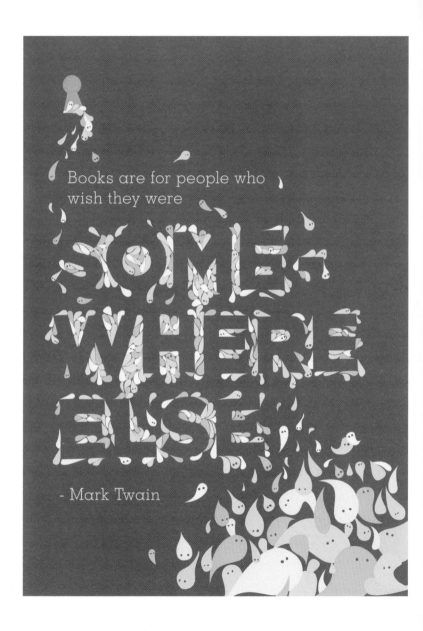

Books are for people who wish they were

SOME-
WHERE
ELSE

- Mark Twain

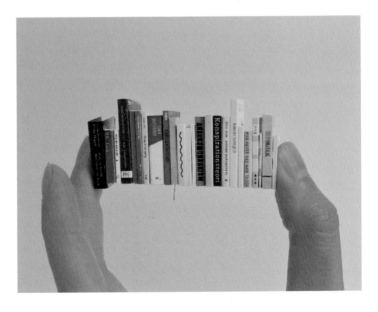

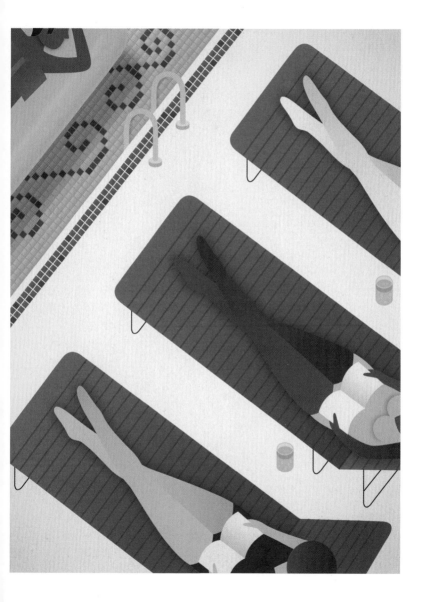

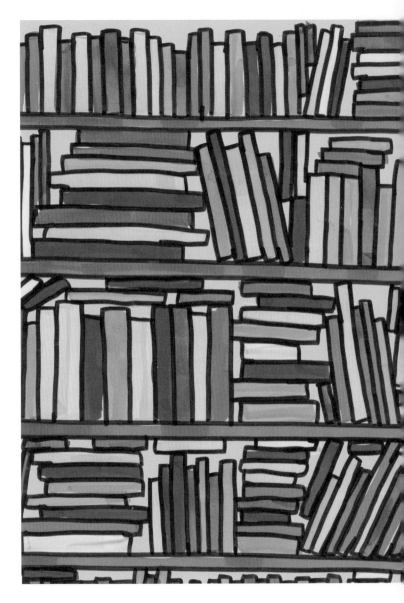

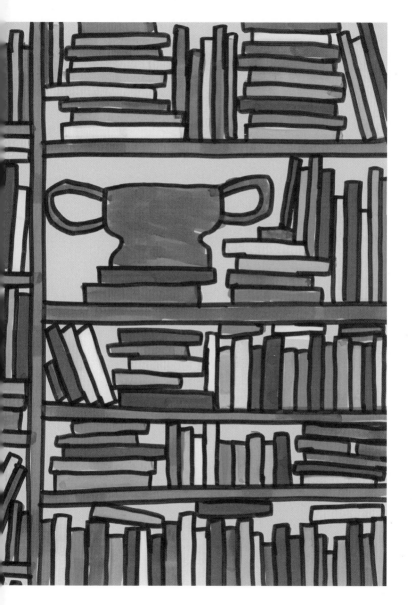

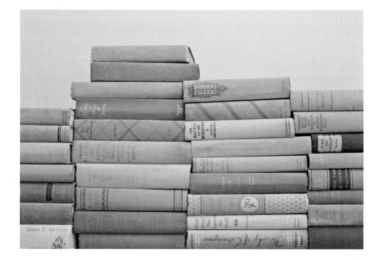

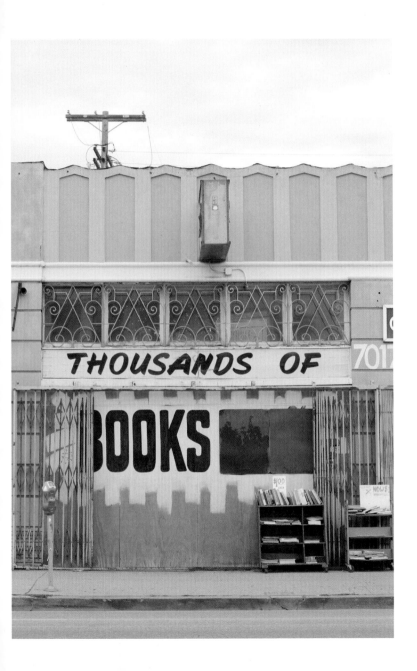

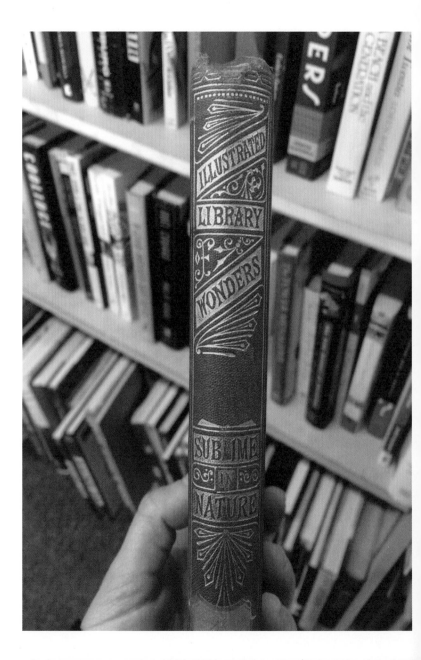

IF I WERE ASKED TO SAY WHAT IS AT ONCE
THE MOST IMPORTANT PRODUCTION OF ART
AND THE THING MOST TO BE LONGED FOR;
I SHOULD ANSWER: A BEAUTIFUL HOUSE;
AND IF I WERE FURTHER ASKED TO NAME
THE PRODUCTION NEXT IN IMPORTANCE
AND THE THING NEXT TO BE LONGED FOR;
I SHOULD ANSWER; A BEAUTIFUL BOOK. TO
ENJOY GOOD HOUSES AND GOOD BOOKS
IN SELF-RESPECT AND DECENT COMFORT,
SEEMS TO ME TO BE THE PLEASURABLE END
TOWARDS WHICH ALL SOCIETIES OF HUMAN
BEINGS OUGHT NOW TO STRUGGLE.

—William Morris (1834–1896)

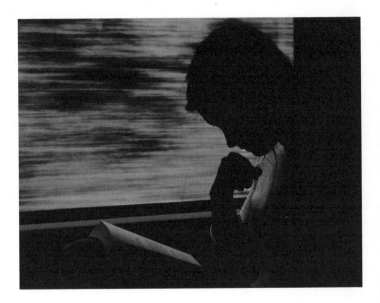

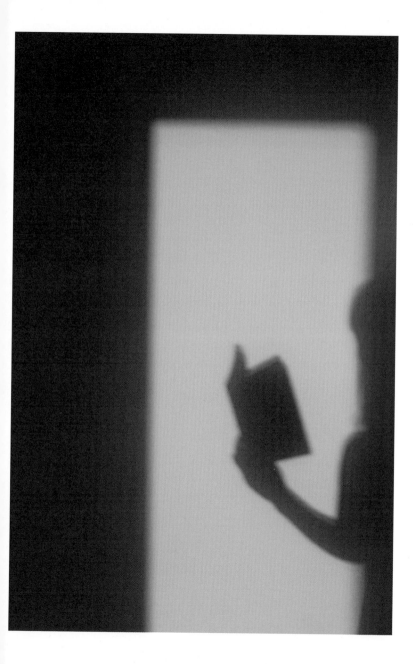

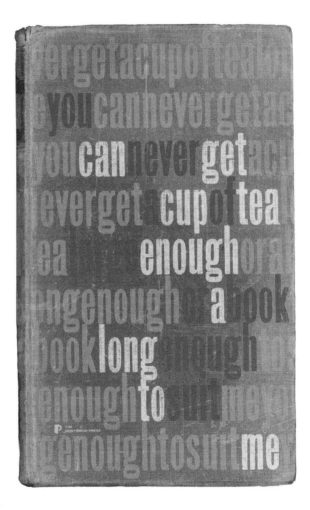

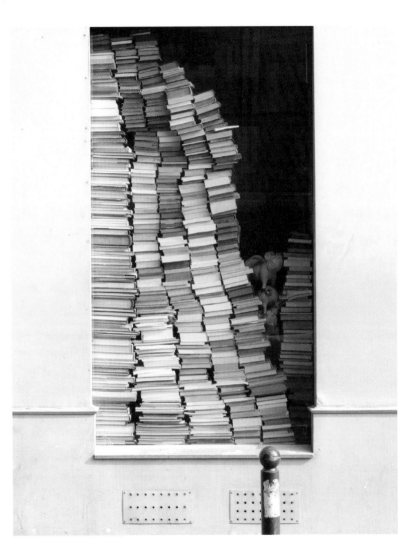

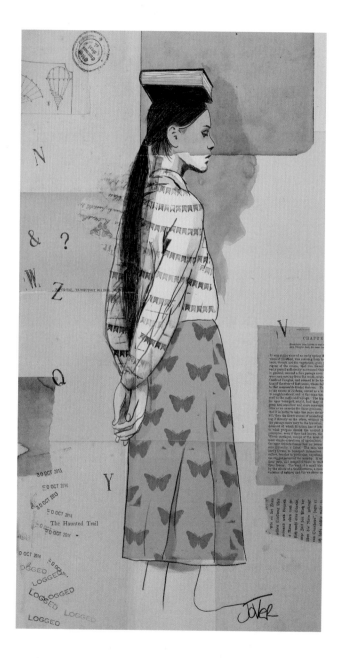

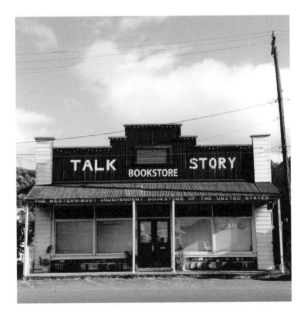

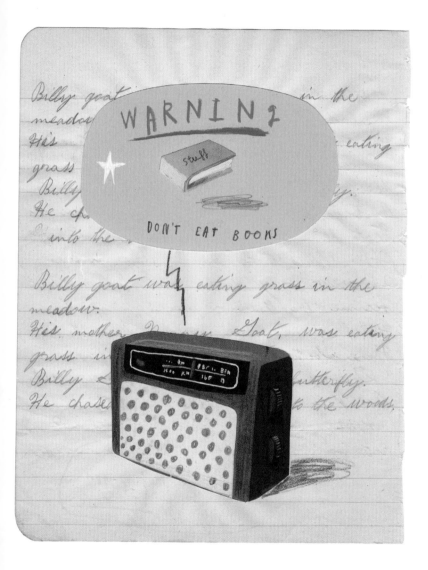

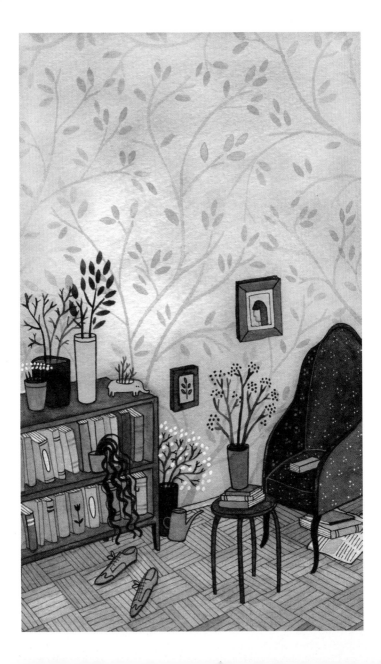

13 Tips

FOR GETTING MORE READING DONE

By Gretchen Rubin

Of my hundreds of happiness-project resolutions, and of the habits I've tried to form, one of my very favorites is to **read more**.

Reading is an essential part of my work. It forms an important part of my social life. And far more important, reading is my favorite thing to do, by a long shot. I'm not a well-rounded person.

But reading takes time, and there aren't many days when I can read as much as I'd like. Here are some habits that I've adopted to help me get more good reading done.

1. QUIT READING.
I used to pride myself on finishing every book I started. No more. Life is short. There are too many wonderful books to read.

2. READ BOOKS YOU ENJOY.
When I'm reading a book I love, I'm astonished by how much time I find to read. Which is another reason to stop reading a book I don't enjoy.

3. WATCH RECORDED TV.

It's much more efficient to watch recorded shows, because you skip the commercials and control when you watch. Then you have more time to read.

4. SKIM.

Especially when reading newspapers and magazines, often I get as much from skimming as I do by a leisurely reading. I have to remind myself to skim, but when I do, I get through material much faster.

5. GET CALM.

I have a sticky note posted in our bedroom that says, "Quiet mind." It's sometimes hard for me to settle down with a book; I keep wanting to jump up and take care of some nagging task. But that's no way to read. Incidentally, one of the main reasons I exercise is to help me sit still for reading and writing—if I don't exercise, I'm too jumpy.

6. DON'T FIGHT MY INCLINATIONS.

Sometimes I feel like I should be reading one book when I actually feel like reading something entirely different. Now I let myself read what I want, because otherwise I end up reading much less.

7. ALWAYS HAVE SOMETHING TO READ.

Never go anywhere empty-handed. I almost always read actual ye olde print books, but I travel with e-books, too, so I know I'll never be caught without something to read. It's a great comfort.

8. MAINTAIN A BIG STACK.

I find that I read much more when I have a pile waiting for me. Right now, I have to admit, my stack is so big that it's a bit alarming, but I'll get it down to a more reasonable size before too long.

9. CHOOSE MY OWN BOOKS.

Books make wonderful gifts—both to receive and to give—but I try not to let myself feel pressured to read a book just because someone has given it to me. I always give a gift book a try, but I no longer keep reading if I don't want to.

10. SET ASIDE TIME TO READ TAXING BOOKS.

For *Better Than Before*, my book about habit formation, I tried a new reading habit: study. Every weekend, I spend time in "study" reading, which covers books that I find fascinating, but that are demanding, and that I might put down and neglect to pick up again. The kind of book that I really do want to read, but somehow keep putting off for months, even years.

And finally, three more tips from great writers and readers:

11. RANDALL JARRELL: "Read at whim! Read at whim!"

12. HENRY DAVID THOREAU: "Read the best books first, or you may not have a chance to read them at all."

13. SAMUEL JOHNSON: "What we read with inclination makes a much stronger impression. If we read without inclination, half the mind is employed in fixing the attention; so there is but one half to be employed on what we read."

Maybe you don't love to read, so finding more time to read isn't a challenge for you. The larger point is to make sure you're finding time to do whatever it is that you find fun. Having fun is important to having a happy life, yet it's all too easy for fun to get pushed aside by other priorities. I have to be careful to make time for reading, or, even though I love to read, I might neglect it.

Also, having fun makes it easy to follow good habits; when we give more to ourselves, we can ask more of ourselves. If reading is a treat for you, it's a good idea to make time for it.

This essay was first published on July 23, 2014, on gretchenrubin.com. Used by permission of the author. All rights reserved.

I am NO bird; & no net ensnares me: I am a FREE human being with an INDEPENDENT will.

Charlotte Brontë, Jane Eyre

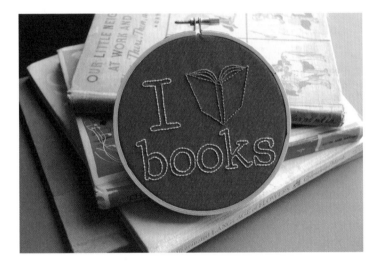

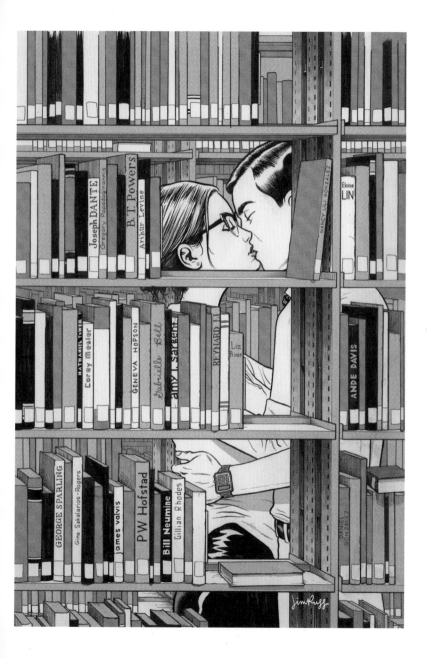

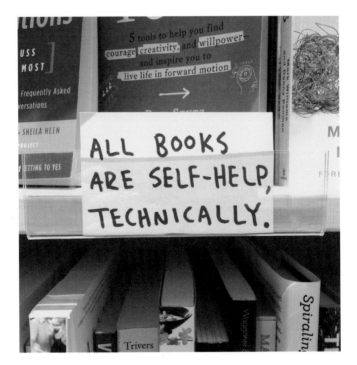

ALL BOOKS
ARE SELF-HELP,
TECHNICALLY.

Acknowledgments

This book would not have been possible without the help and kindness of many, many people. My deepest thanks go out to all the contributors who so generously allowed me to include their work in the book. To Liz and Hannah for moving mountains. To Daniel Kirschen for saying yes. To Maura Kelly, whose words inspired me to start a Slow Books Movement of my own. To Ann Patchett, for leading by example with your tireless support of indie bookstores and for making my contributor dreams come true.

To Gretchen Rubin, for your enthusiasm about this project and the permission to quit reading. To my editor, Bridget Watson Payne, for your incredible eye and your faith in me. To the team at Chronicle Books, Yay Art! To my Silent Book Club cofounders: Kristin Appenbrink and Laura Gluhanich, the best reading-and-drinking buddies a girl could hope for. Thank you to my parents for raising a reader. To Nick, for believing in me. And to Arlo, my everything.

Image Credits

front cover & page 23 Ramon TODO, *Bucharbeiten*, courtesy of Art Front Gallery
back cover & page 2 Courtney Cerruti, @ccerruti, ccerruti.com
page 6 Guinevere de la Mare, silentbook.club
page 9 Lisa Solomon, lisasolomon.com
page 17 Gemma Correll
pages 18 & 19 Jane Mount, *Ideal Bookshelf 753: Shakespeare*. idealbookshelf.com
page 20 MinaLima, Miraphora Mina and Eduardo Lima
page 21 Kate Bingaman-Burt, katebingamanburt.com
page 22 Sandy Lynn Davis, *Less Selfies, More Shelfies*, 2016
page 24 Phil Shaw, *London New York Paris Moscow*
page 25 Marc Johns, marcjohns.com
page 26 Penelope Dullaghan
page 28 Lindsay Crandall
page 29 Chloe Ferres, *Light Reading*. chloeferres.com.au
page 30 Maria Kofinis, instagram.com/booksugar
page 31 Mary Matson, *Joie de Livres*, Poster Design for Book/Shop
page 32 Nathaniel Russell, *Modern Classics*, 2011
page 33 Sophie Blackall
pages 34 & 35 Julia Rothman for *The Washington Post*